Images from
THE OLD TESTAMENT
Historiarum Veteris Testamenti Icones
by Hans
HOLBEIN

Images from THE OLD TESTAMENT

Historiarum Veteris Testamenti Icones by Hans

HOLBEIN

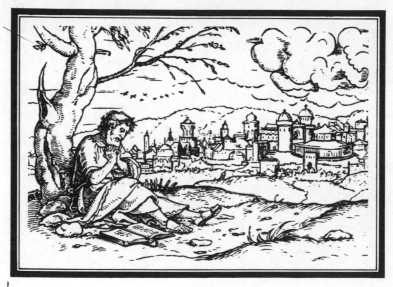

with a
new introduction by
Michael Marqusee

PADDINGTON
Masterpieces of the
Illustrated Book

Library of Congress Cataloging in Publication Data

Holbein, Hans, the Younger, 1497-1543.
Images from the Old Testament — Historiarum
Veteris Testamenti icones.

(Masterpieces of the illustrated book)
Reprint of the 1543 ed. published by Trechsel
and Frellon, Lyons; with new introd.
French and Latin.
1. Holbein, Hans, the Younger, 1497-1543.
2. Bible. O.T.— Pictures, illustrations, etc.
I. Title. II. Title: Historiarum Veteris
Testamenti icones.
NE1150.5.H64A4714 1976 769′.92′4 76-3813
ISBN 0-8467-0147-2

© this edition Paddington Press 1976
© reproductions Trustees of the British Museum 1976

Published by Paddington Press Ltd., New York and London
Printed in England by Balding and Mansell Ltd., Wisbech, Cambs.

INTRODUCTION

Hans Holbein the younger designed over four hundred woodcuts as illustrations for printed books. These included the pictorial series *Historiarum Veteris Testamenti Icones*, the famous *Dance of Death*, and some of the finest title pages and ornamental initials ever designed. Between 1538 and 1549 the Lyons firm of Trechsel and Frellon issued five editions of the *Icones* in Latin and French, and one each in Spanish and English, striking evidence of the international appeal of Holbein's art. Copies of the illustrations appeared in Bibles published in Antwerp, Zurich, and Paris. In a time of increasing religious and secular conflict, Holbein's artistic idiom was applauded and imitated throughout Western Europe.

Holbein was born in Augsburg, at that time an important center of trade between Italy and the North, in the winter of 1497–98. His father, Hans the Elder, was a successful master in the late Gothic tradition, admired today for the delicacy of his silverpoint portrait drawings. Holbein the elder, like other medieval German artists, was renowned for his meticulous craftsmanship, and in his studio Hans the younger, with his older brother Ambrose, would have received rigorous grounding

in the rudiments of painting and drawing. Sometime around 1513 or 1514, the two brothers left Augsburg for Switzerland, and by 1515 they were both working in Basel. Ambrose, a draughtsman of considerable promise, died shortly thereafter. Hans remained in Basel, except for occasional excursions abroad, for the next fifteen years. It is likely that he was first attracted to Basel by its prosperous publishing industry; indeed, he earned much of his livelihood during these early years as a designer of illustrations, title pages, printer's devices, and ornaments.

In the early fifteenth century Basel was the most important intellectual center in the German-speaking world. The university attracted students and intellectuals, among them eminent humanists and future reformers. The printer-publishers of the town were famous for their scholarly editions. Johann Amerbach had founded the tradition in 1477, with the Sorbonne scholar Johann Heynlin serving him as a kind of literary editor. Johann Froben worked in partnership with Amerbach from 1491 to 1513, and after that he and his son Hieronymous established themselves as the pre-eminent publishers of humanist literature in Germany. Their literary advisor and close friend was Desiderius Erasmus, who began visiting Basel annually in 1513 and settled there in 1521. Their most famous productions include complete editions of Jerome and Augustine and Erasmus' edition of the Greek New Testament, which was later to serve as the basis of Luther's translation. In 1515 Holbein drew a witty series of pen sketches in the margins of a copy of Froben's first edition of Erasmus' *Praise of Folly*. This copy belonged to the humanist who called himself Myconius; it is said that he showed the drawings to his friend Erasmus, who praised the work of the artist, then only seventeen years old. In the same year a title page designed by Holbein appeared in Froben's fine edition of Thomas More's *Utopia*, and throughout the next decade he contributed designs to editions of the ancient and modern classics. Title pages and illustrations by Holbein appear in

6

the Basel editions of Luther's New Testament and Psalms, and it is probable that the cuts eventually printed in Lyons as the *Icones* were originally intended for an edition of Luther's Old Testament.

Holbein has left us a record of his involvement with the Basel humanists in several of his early portraits. One of the finest of these is the portrait of Boniface Amerbach, the son of Johann and designated heir of Erasmus, and the only person whom we know to have been a close friend of Holbein. His most famous portraits of these years are the studies of Erasmus at his writing desk. The humanist had been painted a decade earlier in a double portrait with his friend Peter Gilles, known as Aegidius, by the Flemish master Quentin Massys. The domestic intimacy of these portraits seems a perfect expression of the personal links that bound together the geographically dispersed humanist community.

Holbein adopted this intimate approach for his own portraits of Erasmus in preference to that of Dürer, who in 1526 translated his sculptural chalk portrait of Erasmus, drawn six years earlier, into an even more hieratic engraving. We know that Erasmus considered Dürer's engraving a poor likeness, and it is fair to assume that he found Holbein's rendering more congenial, especially as he called Holbein "an artist of great taste" in a letter to Wilibald Pirkheimer, Dürer's oldest and closest friend.

Holbein and Dürer have usually been considered the greatest German masters of the Renaissance, and in the nineteenth century they were seen as the outstanding representatives of the Reformation spirit. But the situation was far more complex. By 1520 Holbein, still in his early twenties, had been recognized by the Basel council as the town's leading artist. In the next decade his fame was to spread throughout Switzerland and southern Germany. Meanwhile, the early alliance of reformers and humanists was coming to an end. At first Erasmus had defended Luther's right to criticize abuses, declaring at the same time his own neutrality. "I am

7

not accusing Luther nor am I defending him nor am I responsible for him." But as Luther insisted ever more vehemently that "he who is not with me is against me," Erasmus was driven to admit that he found Luther's remedy "a violent and bitter medicine." Their final split in 1524, on the same issue of free will, was only the reflection of a deeper division. Erasmus was a lover of moderation; he found it difficult to believe that even the worst abuses of the papacy justified such violent rhetoric: "more can be accomplished by polite constraint than by vehemence . . . on all occasions one must be cautious not to say or do anything with arrogance or a party spirit." To which Luther replied, "you fancy yourself steering more cautiously than Ulysses between Scylla and Charybdis as you seek to assert nothing while appearing to assert something." Dürer in Nuremberg unhesitatingly sided with Luther, and we know from his journal that he resented and suspected Erasmus' neutrality.

In Basel Holbein's situation grew progressively more precarious. The growth of Luther's cause coincided with the growth of iconoclasm. This doctrine – citing the Old Testament commandment, "Thou shalt not make any graven image" – condemned as idolatry the representation of any holy persons or events; its adherents were particularly infuriated by the presence of such representations in the Lord's House. The artist could no longer rely on the commissions for religious paintings, especially of the Virgin and the saints, which for so long had provided the basis of his livelihood. Erasmus adopted a typically qualified view of the matter. He thought "the splendid display of images and statues was a fine thing," but feared that "we are almost slipping into idolatry." Holbein's own position is ambiguous. He designed masterful illustrations for Lutheran polemics criticizing the sale of indulgences and the philosophy of the schoolmen. And I think it is fair to say that his illustrations to the Old Testament evince a vigorous and humane piety much indebted to the new religious ideas. But the iconoclastic strain of Lutheranism

8

soon grew so predominant that the illustrations were only to appear, over a decade later, in Catholic France.

Holbein left Basel in 1526 armed with a letter of introduction from Erasmus to Aegidius in Antwerp, explaining that "here the arts are shivering with cold; [Holbein] is going to England to pick up a few angels." He also provided the young artist with an introduction to Thomas More, who wrote back: "your painter, my dear Erasmus, is a marvelous artist, but I am afraid he may not find England as profitable as he hopes." Nonetheless, Holbein did make important contacts with English patrons, and painted the now lost group portrait of the More family, a sketch for which he presented to Erasmus on his return to Basel in 1528. His own religious position remained ambiguous. The records of the Christian recruitment, as the Reformers were called in Basel, state that Holbein required a better explanation of Holy Communion before he would join. He did join eventually but I wonder if this was anything more than an appeasing gesture. In February of 1529, during the Shrove Tuesday festivities, mobs entered the Cathedral and churches of Basel and destroyed – by whitewash, pickax and fire – every painting and sculpture they could lay their hands on. It is possible that Holbein witnessed the immolation of several of his major achievements. Erasmus was deeply shocked by the violence of the *Bildersturm*, and moved from Basel later in the same year. Holbein purchased a house for his wife and children, painted their portrait, and left for England by himself in 1531.

By the time he arrived in London his former patron More had resigned the Lord Chancellorship in opposition to the King's impending break with Rome. For several years Holbein was supported by commissions from the community of German-speaking merchants who had their own designated district of residence within the city. He must have soon become known as the most skillful artist in the country, and over the next few years he was employed ever more frequently by diplomats and courtiers. More was executed in 1535 and in

1536 Holbein became Henry VIII's official court painter, with a studio in Windsor Castle. In this capacity he painted some of his most famous portraits. He was admitted to the heavily guarded presence of the infant Prince Edward to draw his portrait, and Henry had enough faith in the artist's skill to commission him to paint one of his prospective brides, a girl the King himself had never seen. He continued in the King's service until his death in the plague that broke out in London in 1543. While in England he painted several monumental frescoes, but unfortunately these have all been destroyed or repainted beyond recognition. He learned the art of miniature portraiture and quickly became one of its greatest practitioners. He designed illustrations and title pages, but the English woodcutters were rarely able to do justice to his supple designs. And he produced a great number of exquisite and endlessly inventive designs for such articles as clocks, sheaths, daggers, mirrors, stained glass, chalices, vases, and medallions.

Although he has always been recognized as one of the greatest masters of the Northern Renaissance, Holbein's position in the history of art is singularly difficult to define. A painter of minutely detailed portraits and freely inspired decorative designs, of large-scale frescoes and miniature printer's initials, may well be considered an anomaly. The immensity of his talent, its early fruition, and the odd circumstances of his career place him outside the laws of stylistic classification. In his father's studio he would have been subject to the influence of the German late Gothic school, with its taste for meticulous decorative elaboration. The Northern tradition of detailed representation, particularly of familiar household objects, can be seen in the early table painting known as the *Picture of Nobody*, now in Zurich. This careful attention to detail persists in his art to the very end, and can be found in the miraculous renditions of clothing and jewels which enliven even his most solemn late portraits. The influence of Dürer's early work, particularly the emotive

10

Apocalypse and Passion woodcuts, is equally profound but more difficult to trace. It can be seen in the early painting of *Adam and Eve*, which could be mistaken for a work by Hans Baldung, and in his early paintings and drawings of the Passion, with their contorted figures and bold facial expressions. Thereafter, Dürer's influence becomes an underground current, submerged by that of the Italian High Renaissance.

Dürer was already a mature master in the German style when he began his serious study of Italian Renaissance developments. Holbein was exposed to the new forms at a much earlier stage of his career, and his adaptations of them evince none of the conscientious struggle that we find in Dürer's. The artist Hans Burgkmair, who was probably an acquaintance of both the elder and the younger Holbein, introduced Renaissance ideas to Augsburg on his return from Italy in 1508. In his drawings and woodcuts Holbein may have encountered for the first time the new elegance and breadth of the Italian works. Holbein spent a good deal of the year in 1517 in Lucerne, and it has often been noted that from there he could very easily have crossed the mountains into northern Italy. Though Karel van Mander, the often unreliable Vasari of the North, states that "Holbein never traveled to Italy," there is little doubt that the influence of Mantegna and Leonardo is manifest after 1519 and grows stronger throughout the following decade. Holbein's understanding of large-scale perspective, as seen in his drawings and in the surviving fragments of larger paintings, was greater than that of any other German artist of the time. And his ability to use that perspective, especially in the form of architectural motifs, to enhance the drama and dignity of his narrative scenes shows a remarkable intellectual penetration into Italian art. He may have encountered Leonardo's influence again when he traveled in France in 1524, possibly in hopes of succeeding him as court painter to François I. The influence can be seen in the new depth and softness of his portraits: both the contours of the drawing and the handling of paint are disguised

11

in the search for an overall effect. His group portraits, the Solothurn and Darmstadt Madonnas and the portrait of his wife and two children, have a formal balance and color harmony very different from the tradition of Massys. Their deceptively casual composition gives these works, as well as the drawings for larger projects, a new unity and gravity. Nothing is overstated; no expression or gesture calls attention to itself. As Holbein's art develops in England in the 1530's this restraint becomes a deliberately static brilliance. Surfaces are rendered with even more exactitude; the subjects are posed with cold formality. Yet beneath this formality and virtuosity the power of characterization has attained a greater subtlety.

What is common to all Holbein's mature works is a special clarity, a concentration of means and effect. His love of detail is rightly praised, but he is never led by this love to become finicky or affected. Holbein was a master of both line and surface texture and therefore his style cannot be characterized as either linear, like Dürer's, or painterly, like Titian's; indeed, his work as a whole may be said to reveal the inadequacy of the dualism. His keen observation of surfaces is only the other side of his development of powerful underlying structures. The miraculous modeling of his portraits or the simplicity of the *Icones*, achieved without condensation or exaggeration, is the product of an unfailing understanding of how one effect can only be judged in the context of another. Holbein's achievement is as difficult to define as its appeal is universal. Perhaps it is really this paradox we refer to when we call his achievement classic or definitive.

His religious works are equally resistant to facile categorization. Though many of these have vanished, it seems clear that Holbein was never a devotional or emotive religious artist, as Grünewald and Bellini were in their different ways. His Madonnas are marked by a sober reticence; they are not so much tranquil or serene as thoughtful and preoccupied. This same reticence emerges in a very different form in his large

12

painting of the *Dead Christ*, an unstintingly accurate depiction of the human corpse in which the effects of death only enhance the grandeur of the figure. Here the horrors of death are not expressionistically heightened; they are merely portrayed and thus allowed to speak for themselves. This is also true of the *Dance of Death*: The skeletons are stylized and there are no images of carnage or bodily decay or any displays of overwhelming grief. The theme of the unpredictable ubiquity of death is simply stated over and over again.

It has always been assumed that the *Dance of Death* and the *Icones* were designed at approximately the same time – in the mid 1520's, in Basel. We know that the *Dance of Death* series was cut by Hans Lutzelburger, whose subtle and minute translations of Holbein's designs make him one of the greatest European woodcutters. The designs themselves, forty-one in the early editions, are superb examples of the point which a miniature format can add to a satirical statement. Like the Alphabets that Lutzelburger also cut for Holbein, they present in their modest dimensions a rhythmic progression of moving figures in which difficult foreshortenings and an economical suggestion of three-dimensional space are compressed into a lively ornamental pattern. The first four cuts in the *Icones* are in fact the first four from the *Dance of Death*. Holbein's original blocks for the Creation and the Fall must have been either lost or destroyed in the time between their creation in Basel and their first publication in Lyons in 1538, which is also the date of the first publication of the *Dance of Death*. It is thought that the blocks entered the possession of the Trechsel brothers (whose motto, *Matura*, with the device borrowed from the Emperor Augustus, the crab and the butterfly, appears at the back of the book). With their successors the Frellons they were to publish many editions of both series over the next decade, as a repayment by Lutzelburger's widow of an old debt. But not all critics are convinced that Lutzelburger cut the *Icones* as well as the *Dance*. Clearly such poor productions as the Zachariah and

the Joel could not be from the same hand as the *Dance*. In others, such as the schematic cuts representing the arrangement of altar and temple and the genealogy of empires, there is little evidence of an original design by Holbein. And even the best cuts differ in several respects from the *Dance*. Their larger, horizontal format allowed for a more spacious design; the figures are less cramped, the modeling and shadow indicated less forcefully. In general, there is less detail. It has been suggested that they were designed in 1530, six years later than the *Dance*, when drawings of Biblical subjects in a similar style can be dated.

The differences between the two series may be explained as well by their differences in intention. The *Dance*, descended from a well-established tradition, resembles those ornamental grotesques that appear like incidental jokes in medieval manuscripts and cathedrals. The Bible cuts are intended to represent complex events from a fully developed narrative literature. This required, on the one hand, greater space in which to delineate the complex events and, on the other hand, a simplification of form in the interests of clear exposition. In this respect Holbein has been particularly successful. The *Icones,* unlike many Bible illustrations, only gain in meaning when read in their Biblical context. Holbein is fascinated by the narrative power of the Old Testament, particularly the books of Genesis, Exodus, Samuel, Kings and Chronicles. He had always been interested in telling stories with pictures; the sheer difficulty of it must have appealed to him. His title pages and architectural designs are filled with narrative vignettes, half-told tales, suggestions of great events. What he could have done with classical mythology! But at this time the German-speaking countries had little interest in the illustration of ancient literature, and by 1529 it had become dangerous to tell even a Biblical story in pictures.

One of the principles of Biblical narrative is that the actions of men have a greater significance than they can know because they participate in the cosmic history of God and his

14

people. Holbein respects this principle by conceiving his illustrations in a grand and serious style. It is useful to remember that Holbein was at work on large-scale wall paintings in the town hall and elsewhere in Basel during the period in which he created the *Icones*. And in these woodcuts we do indeed find the momentous confrontations and heroic gestures usually reserved for frescoes placed many feet above the eye-level of mere mortals.

This grand conception would have seemed merely gross if Holbein had failed to create, within the small rectangle on the printed page, a convincing expanse of three-dimensional space. His success in this regard is, for me, one of the qualities that make these woodcuts among the greatest examples of graphic art in the West. We feel we could step into the tiny world of the *Icones* and still breathe easily. Holbein's special understanding of the third dimension is manifest in his early use of motifs from Italian Renaissance architecture; in many compositions from the 1520's figures are integrated into architectural settings with wonderful freedom and inventiveness. The same may be seen, in highly simplified form, in cuts such as Moses lecturing (number 30) or Solomon dedicating the temple (number 58). Architectural forms also appear in many of the title pages; the presence of a logically three-dimensional structure in a decorative context is evidence of Holbein's mistrust of the capricious, of mere elaboration. On the other hand, he had no interest in rigid geometrical consistency. He was aware of the ambiguities of depth-perception; he knew that depth is an interpretation by the eye of patterns that may be read in other ways. He sought therefore to evoke the feeling of open space without necessarily adhering to any strict scheme of linear perspective. Hence the success of such splendid outdoor scenes as the return from exile, Moses and the burning bush, the tower of Babel, and the collection of manna. In none of these does Holbein show any interest in landscape for its own sake. Indeed, it is one of the few genres not represented in his work, even as

15

a background to a portrait. What attracts him is the use of space for dramatic construction, for enriching the human meaning of events. To this end he seeks to suggest space by the simplest means. The woodcut medium and the size of the design demanded a schematization which Holbein exploited brilliantly. He creates the illusion of open air by a deft manipulation of the meager lines that indicate foreground and background, and by a variation of the sizes of his human figures.

The skillfully deployed modeling lines make these figures supple and solid as figures in woodcuts rarely are. The technique is very different from the expressively calligraphic modeling of Dürer's woodcuts. The merest hint of roundness, often just a few strokes on the edge of a face or limb, somehow suggests the full bulk of flesh and blood. And yet, at the same time, the delicacy of the lines – whoever cut the wood was indeed a master – allows the bodies to move lightly through the open space Holbein creates for them. Above all, Holbein's understanding of perspective and foreshortening is always exact. Whether it is Tobias sitting at home or a soldier hacking off the fingers of a king (34) or Ruth gleaning the grain, the arrangement of the parts of the body is always manifestly logical. The position of the figure in space is completely determined and we apprehend it at a glance. It is the work of a great draughtsman, accomplished, as the woodcut medium demands, with the fewest possible lines.

The Bible tells us mainly what people did and said, not how they appeared or what they felt. It is the illustrator's task to interpret this scanty narrative. Holbein responds to the challenge with great sensitivity. His characterizations are various and subtle: the anguish of Nehemiah (62); the troubled sleep of Pharaoh (11); David's thoughtfulness as he composes the Psalms (71), the scorn of Job's friends (66), the equanimity of Judith as she passes Holofernes' severed head to her maid (70). In all of these Holbein has made the dramatic situation credible by showing his figures responding to the

16

action; their features betray their involvement in the events, giving them a recognizable human meaning. The faces on these figures are not, however, portraits. They can rarely be distinguished by their physiognomies. Everything but the expression has been suppressed. Again, the limitations of the size and material demand this simplification. But the necessary economy does not become a boring schematization. The arrangement of the figures in the composition and the exact placement of the few lines that indicate the face – cut usually with the greatest delicacy – transform this featurelessness into a source of subtle refinement. This is especially true in the complex and ambiguous illustrations of the sacrifice of Isaac (8) and of Jacob cheating Esau of his blessing (9). These figures are heavy with the weight of their moral confusion. Neither sinners nor just men, they earn their heroic treatment by virtue of their flawed humanity.

In refusing to oversimplify in his characterizations (even the Fool of the Psalms is neither tragic nor comic), Holbein leaves much of the scene open, as it should be, to interpretation. The ambivalence of the drama is its richness, which can never be exhausted by prolonged acquaintance. The same can be said of his great portraits: The more we feel we know someone from a Holbein portrait, the less we are to put what we know about him or her into words. Of course, this is true of all great portraiture. But its application to Holbein should make us wonder about his famous "objectivity," his attention to appearances. Perhaps this objectivity is really a form of careful restraint, a reluctance to exaggerate or state things one-sidedly.

It is this restraint that makes it so difficult to define Holbein's achievement and, even more, to imagine what kind of person he was. We know very little about him, especially compared to what we know of Dürer, who left behind so many revealing personal documents. Dürer was a man of theories and opinions, an artist whose style is manifest in every stroke of his pen, whose monogram is emblazoned on almost all his

17

creations. Holbein practiced his virtuosity in silence, repressing stylistic flamboyance and idiosyncrasy, leaving almost all major works, including the *Icones*, without a signature or date. Panofsky has said that Dürer and Erasmus respected but did not understand each other, while Holbein and Erasmus understood but did not respect each other. After Holbein had left Basel for the second time Erasmus wrote to a friend that Holbein had betrayed those to whom he was recommended in England, and implied that he would do anything to further his own career. Perhaps Erasmus saw in Holbein a dark mirror wherein his own moderation and tact appeared as a time-serving cautiousness. And perhaps Holbein could see in the humanist's circumspection only a contemptible timidity. Of course, these speculations belong in a novel and not in an art history, but I think it is fair to describe Holbein as a man of discretion, and such discretion, despite occasional outbursts of offensive sarcasm, would inevitably appear as coldness and reserve. It is not hard to see these traits in his self-portraits – but then one can read almost anything into a self-portrait. Nonetheless, one wonders how Holbein secured his intimacy with the family of Henry VIII, where he survived through three of the King's marriages. Certainly his by-words were caution and restraint, whether in exercising what surely was the most prodigious talent of his generation north of the Alps, or in expressing those feelings which it is naive to assume that any man at any time does not possess. Only in Holbein's *oeuvre* could the restrained grief of the portrait of his family appear as an emotional outburst.

Throughout the Bible we are presented with the spectacle of men entering history by the mere act of speech. Somehow by opening their mouths they become heroic figures. Not surprisingly, most artists have difficulty in illustrating this aspect of Biblical literature. But Holbein had the advantage of seeing this ancient spectacle re-enacted in his own time. Luther and dozens of lesser-known reformers had set the world in turmoil by doing nothing more, from their own point

of view, than preaching the word of God. And, like the Old Testament prophets, they emphasized their loneliness in undertaking the heroic action of speech. No doubt Holbein was influenced by their example in his marvelous images of Moses, Amos, Job, and Isaiah speaking out to what was usually a deaf humanity. Holbein, as we know, though sympathetic, shied away from the reformers' cause. But in these cuts he can portray their act and, in a sense, take part in it, without committing himself to their cause – simply because the pictures remain silent. To look at the powerful image of Isaiah prophesying is a different experience from listening to Isaiah prophesying. There is a strange tension in this evocation of speech in a silent medium. We are made conscious that *Loquax enim res est tacita pictum*, as Erasmus said; silent art is rather eloquent. Nothing has been said, yet we feel as if it had. Of course, all art is silent just as all music is invisible. And all artists exploit this silence in their own way. But I think the element of silence is especially useful in explaining the art of Holbein. I have discussed his reluctance to exaggerate or unduly emphasize any one side of a situation, and in this context both his classicism and his respect for details may be seen as ways of remaining silent through art. And when the critic tries to label these things, is he not trespassing on that zone of silence in which the work of art exercises its power? Our words are, indeed, a meager substitute for the eloquence of *tacita pictum*.

<div align="right">MICHAEL MARQUSEE</div>

LIST OF ILLUSTRATIONS

17 *Exodus 16:* Moses supervises the collection of manna.
18 *Exodus 19:* Moses speaks to God on Mt. Sinai.
19 *Exodus 25:* Furnishings for the tabernacle.
20 *Exodus 34:* Moses on Sinai with the second tablets.
21 *Leviticus 1:* God instructs Moses concerning the holocaust.
22 *Leviticus 8:* God instructs Moses to make Aaron and his sons priests.
23 *Leviticus 10:* The sons of Aaron consumed by fire because of their unlawful conduct.
24 *Leviticus 19:* God instructs Moses in the laws of worship and social conduct.
25 *Numbers 1:* Moses and Aaron take the census of Israel.
26 *Numbers 2:* The order of the tribes of Israel.
27 *Numbers 16:* Korah is punished for his rebellion.
28 *Numbers 21:* The people are saved from the fiery serpents by the bronze serpent made by Moses.
29 *Numbers 31:* After their victory over the Midianites, Moses orders the Israelites to kill all except the virgin women.
30 *Deuteronomy 1:* Moses instructing the people.
31 *Deuteronomy 4:* Moses instructing the people.
32 *Deuteronomy 18:* Moses instructing the people.
33 *Joshua 12:* Joshua conquered thirty-one kings west of the Jordan.
34 *Judges 1:* Adonizadek, the king of the Canaanites, has his thumbs cut off by the Israelites.
35 *Ruth 2:* Ruth the Moabite gleaning in Boaz's fields.
36 *1 Samuel 1:* Hannah grieves because she has no child.
37 *1 Samuel 10:* The anointment of Saul by Samuel and the two men at Rachel's tomb.
38 *1 Samuel 17:* David and Goliath.
39 *1 Samuel 23:* David and Saul.
40 *2 Samuel 1:* David learns of the death of Samuel and Jonathan.
41 *2 Samuel 8:* David defeats Hadadezer and hamstrings all his chariot teams.
42 *2 Samuel 11:* David sends Uriah into battle.

22

67 *Job 38 & 42:* Job hears the voice out of the whirlwind and receives money from his friends.
68 *Esther 1 & 2:* Esther presented to Ahasuerus.
69 *Judith 10:* Judith leaving the city.
70 *Judith 13:* Judith beheads the drunken Holofernes.
71 *Psalm 1:* David composing the Psalms.
72 *Psalm 52:* "The fool says in his heart there is no God."
73 *Psalm 109:* The trinity.
74 *Song of Songs 1:* The bride and the bridegroom in the garden.
75 *Isaiah 1:* Isaiah prophesying.
76 *Isaiah 6:* Isaiah's mouth purified by the angel with a coal.
77 *Isaiah 38:* The sundial showing the sun retreating at Isaiah's command.
78 *Ezekiel 1:* A vision of Ezekiel.
79 *Ezekiel 40:* The east gate of Jerusalem.
80 *Ezekiel 43:* The holy altar.
81 *Ezekiel 47:* The new Jerusalem and its twelve gates.
82 *Daniel 4:* Shadrach, Meshach, and Abednego survive Nebuchadnezzar's furnace.
83 *Daniel 7:* A vision of the four beasts.
84 *Daniel 8:* Gabriel explains the meaning of Daniel's dream.
85 *Daniel 11:* Chart of empires.
86 *Daniel 13:* Daniel judges the elders for spying on Susanna
87 *Daniel 14:* The angel carries Habakkuk from Judaea to feed Daniel in the Lion's den.
88 *Hosea 1:* Hosea marries a whore.
89 *Joel 1:* Joel prophesies.
90 *Amos 1:* Amos prophesies.
91 *Jonah 1, 2 & 3:* Jonah outside of Nineveh.
92 *Habakkuk 1:* Habakkuk prophesies.
93 *Zachariah 1:* Zachariah prophesies.
94 *2 Maccabees 5:* Apparitions of horsemen appear over Jerusalem.

Historiarum Veteris Testamenti icones

ad viuum expressæ.

Vnà cum breui, sed quoad fieri potuit, dilucida earundem & Latina & Gallica expositione.

*

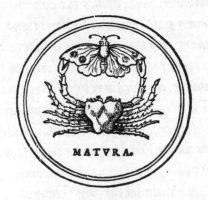

MATVRA.

Lugduni,

Sub scuto COLONIENSI, apud Ioannem & Franciscum Frellonios, fratres.

M. D. XLIII.

FRANCISCVS FRELLONIVS

CHRISTIANO LECTORI S.

E N tibi, Christiane lector, sacrorum canonum tabulas, cum earundem & Latina & Gallica interpreta
tione officiosè exhibemus: illud in primis admonentes, vt reiectis Veneris & Dianæ, cæterarumq́; dea
rum libidinosis imaginibus, quæ animum vel errore
impediunt, vel turpitudine labefactant, ad h.vs sacro
sanctas icones, quæ Hagiographorum penetralia di
gito commonstrant, omnes tui conatus referantur.
Quid enim pulchrius, aut Christiano homine dignius, quàm ad h.vs res animum adijcere, quæ solæ fi
dei mysteria sapiunt, & Deum creatorem nostrum
vnicè amare, ac veram religionem profiteri præcipiunt? Tuum igitur erit hunc nostrum laborem æquo
animo suscipere, ac cæteros cõmonefacere, vt eiusmodi omnia ad Dei largitoris beneficentiβimi glo
riam & honorem dirigere meminerint.

Vale lector, & fruere.

Nicolai Borbonii Vandope-

rani poëtæ Lingonensis, ad Lectorem
Carmen.

VPER in Elysio càm fortè erraret
Apelles,
Vnà aderat Zeusis, Parrhasiusᗱ
comes.
Hi duo multa satis fundebant verba:sed ille
Interea mœrens & taciturnus erat.
Mirantur comites, fariᗱ hortâtur, & vrgent:
Suspirans imo pectore Côus, ait:
O famæ ignari, superis quæ nuper ab oris
(Vana vtinã)Stygias venit advſᗱ domos.
Scilicet, esse hodie quêdã ex mortalibus vnũ,
Ostendat qui me vosᗱ fuisse nihil.
Qui nos declaret Pictores nomine tantum,
Picturæᗱ omnes antè fuisse rudes.
HOLBIVS est homini nomen, q̃ nomina nostra
Obscura ex claris, ac prope nulla facit.
Talis apud Manes querimonia fertur:& illos
Sic equidem meritò censeo posse queri.
Nã tabulã si q̃s videat, quã pixerit *HANSVS*
HOLBIVS ille artis gloria prima suæ,

A ij

Protinus exclamet, Potuit Deus edere mõstrũ
 Quod video:humanæ nõ potuere manus.
Icones hæ ſacræ tanti ſunt (optime lec̃tor)
 Artificis, dignum quod venereris opus.
Proderit hac pictura animum pauiſſe ſalubri,
 Quæ tibi diuinas exprimit hiſtorias.
Tradidit arcano quæcuncჳ volumine Moſes,
 Totცჳ alij vates gens agitata Deo,
His Hanſi tabulis repræſentantur : & vnà
 Interpres rerum ſermo Latinus adeſt.
Hæc legito. Valeat rapti Ganymedis amator:
 Sintცჳ procul Cypriæ turpia furta deæ.

 Eiuſdem Borbonij Poëtæ Δίϛιχον.

Ω ξέν᾽ ἰδ᾽ ἄιμ ἔιδ᾽ωλα ϑέλεις ἐμπνώισιμ ὁμοῖα;
 ΟλΒιακῆς ἔργον δ᾽έρχεο τῦτο χερός.

 Latinè idem penè ad verbum.

Cernere vis, hoſpes, ſimulacra ſimillimaviuis?
Hoc opus Holbinæ nobile cerne manus.

Gilles Corrozet
aux Lecteurs.

EN regardant ceste tapisserie
L'œil corporel, qui se tourne & varie,
Y peult auoir vn singulier plaisir,
Lequel engendre au cœur vn grand desir
D'aymer son Dieu, qui a faict tant de choses
Dedans la letre & saincte Bible encloses.

 Ces beaux pourtraictz seruiront d'exemplaire
Comment il fault au Seigneur Dieu complaire :
Exciteront de luy faire seruice,
Retireront de tout peché & vice
Quand ilz seront insculpez en l'esprit
Comme ilz sont painctz, & couchez par escript.

 Doncques ostez de voz maisons & salles,
Tant de tapiz & de peintures sales,
Ostez Venus & son filz Cupido,
Ostez Helene & Philis & Dido,
Ostez du tout fables & poësies
Et receuez meilleures fantasies.

<div align="right">A iij</div>

Mectez au lieu, & soient noz chambres ceinctes
Des dictz sacrez, & des histoires sainctes
Telles que sont celles que voiez cy
En ce liuret. Et si faictes ainsy,
Grandz & petis, les ieunes & les vieulx
Auront plaisir, & au cœur & aux yeulx.

Plus que moins.

DEI Omnipotentis uerbo creantur ac bene-
dicuntur terra, dies, nox, cœlum, mare, fol,
luna, ſtellæ, piſces, & beſtiæ terræ. Crean-
tur quoǫ Adam & Heua.

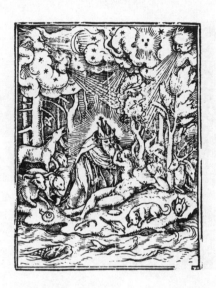

Dieu feit le Ciel des le commencement
Puis Terre & Mer, & tout humain ouurage:
Adam & Eue il feit ſemblablement
Pleins de raiſon formez à ſon image.

ADAM in Paradiſo uoluptatis conſtituitur,
cui interdicitur Ligno uitæ. Serpentis aſtu
tia Adam & Heua ſeducuntur.

GENESIS II. & III.

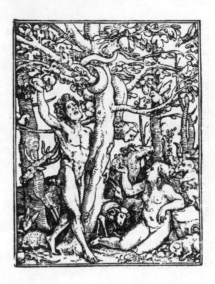

Dieu leur deffend que de l'arbre de Vie
Ne mangent fruict, ſur peine de la Mort:
Mais le Serpent, ayant ſur eulx enuie,
Fait tant qu'Adam au fruict de l'arbre mord.

A D A M & H E V A cognito peccato suffu-
giunt faciem D E I, ac Morti obrjciuntur.
Cherubim ante Paradiſum uoluptatis cum
flammeo gladio collocatur.

GENESIS III.

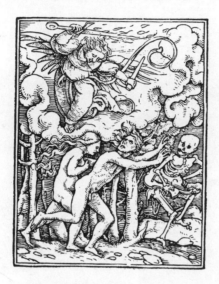

Pour le peché qu'ilz feirent contre Dieu
Furent mauldictz chaſcun ſelon l'offence:
Puis Cherubim les meƈt hors de ce lieu,
Et contre Mort n'eurent plus de deſſence.

B

ADAM iubetur fodere & arare terram, eie-
ctus è paradiſo. Mulier ſub uiri poteſtate
conſtituitur, & in dolore parit.

GENESIS III.

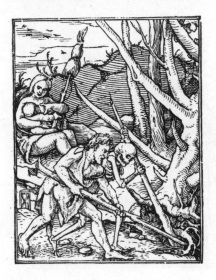

En grand labeur & ſueur de ſon corps
Le viel Adam a ſa vie gaignée :
Eue tandis faiſoit tous ſes effortz
D'entretenir & nourrir ſa lignée.

NOE iuſtus iuſſu Domini arcam ingreditur:
cæteris præter ſe & ſuos diluuio interem-
ptis, ſeruatur. Emiſsis coruo & columba,
ex arca egreditur.

GENESIS VII.

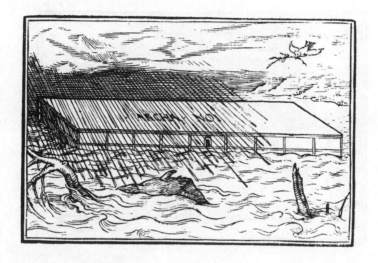

Tous les humains par l'vniuers deluge
Furent peris : Noë le Patriarche
(Du vueil de Dieu) pour ſe mettre à refuge
Auec les ſiens, entra dedans ſon arche.

BABEL turris ædificatur, ex qua linguarum confusio suboritur.

GENESIS XI.

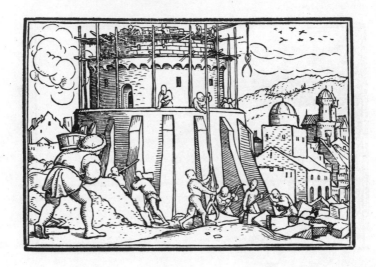

Nembroth geant commenca à construire
La Tour Babel, dicte Confusion:
Mais Dieu voulant si grand orgueil destruire,
Mit au languaige vne diuision.

ABRAHAM hofpitio fufcipit Angelos. Pro
mittitur ei Ifaac. Poft hoftium tabernaculi
ridet Sara. Sodomorum interitus Abrahæ
prædicitur. Orat pro Sodomitis.

GENESIS XVIII.

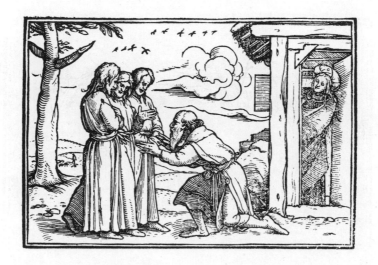

A Abraham les Anges ont promis
D'auoir vn filz, Sara n'en faict que rire:
A deux genoulx pour Sodome s'eſt mis,
En priant Dieu de retarder ſon ire.

ABRAHAE fides tentatur, Filium ſuum Iſaac
immolare iubetur. Angelus Abraham ac-
clamat, ne filium occidat.

GENESIS XXII.

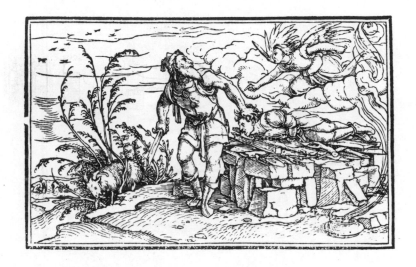

Dieu commanda à Abraham de faire
De ſon enfant Iſaac ſacrifice :
Au mandemant voulant doncq ſatisfaire,
Dieu fut content de ſa Foy & Iuſtice.

B ij

I A C O B per aſtutiam matris præripit bene-
dictionem Eſau. Triſtatur Iſaac. Eſau con-
ſolatur.

GENESIS XXVII.

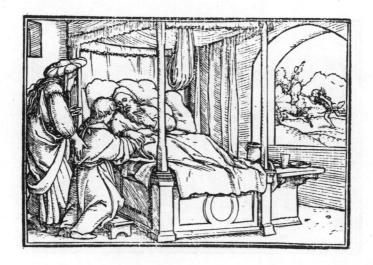

Le bon Iacob par conſeil de ſa mere
Eut d'Iſaac la benediction,
En ſe faignant eſtre Eſau ſon frere,
Qui ſe marrit de la deception.

IOSEPH quòd accusarit fratres, & somnia ui
derit, in cisternam mittitur. E cisterna ex-
tractus, Ismahelitis uenditur.

GENESIS XXXVII.

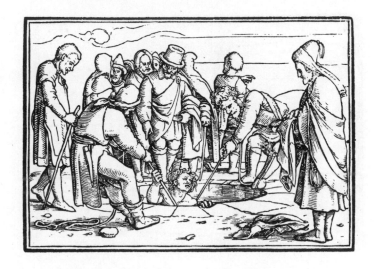

L'enfant Ioseph à ses freres predict
Vng songe sien : parquoy en la cisterne
L'ont enfermé : mais Dieu qui tout gouuerne
A des marchans permit qu'on le vendit.

PHARAONIS somnia de septem bobus &
spicis, eductus è carcere Ioseph exponit. Su-
per annonam Aegypti constituitur.

GENESIS XLI.

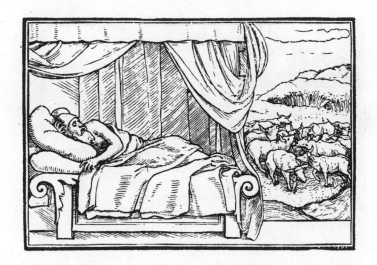

Au souef dormir Pharaon se dispose,
Sept espicz voit & sept bœufz en songeant,
Ioseph mis hors de prison, luy expose :
Qui sur Egypte est faict maistre & regent.

C

IACOB moriturus adoptat sibi Ephráim
& Manassem, filios Ioseph; benedicítque
eisdem.

GENESIS XLVIII.

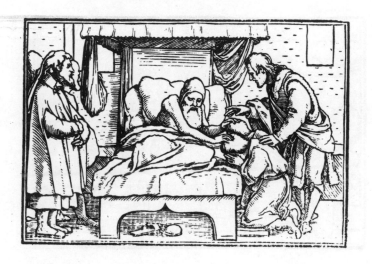

Iacob voyant le sien eage prefix,
Et que la mort faisoit sur luy exces,
Il adopta de Ioseph les deux filz,
L'vn Ephraim, & l'autre Manasses.

IOSEPH sepelitur. Filij Israël in Aegypto
dura seruitute opprimuntur. Obstetricum
piarum industria exprimitur.

EXODI I.

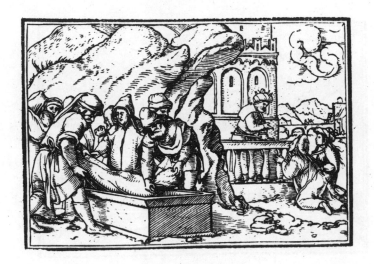

Ioseph est mort & mis en sepulture,
Israël seuffre vne grand tyrannie :
Matrones sont de si doulce nature,
Qu'elz ont sauué à tous masles la vie.

<div align="right">C ij</div>

MOYSES paſcit oues. Videt DEVM in ru-
bo. Mittitur ad filios Iſraël, & Pharaonem
oppreſſorem.

EXODI III.

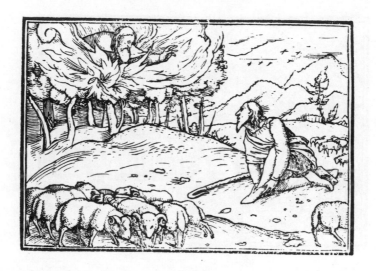

Le bon Moyſe en ſes brebis gardant
Veit noſtre Dieu en vn buiſſon ardant,
Lequel l'enuoye à Pharaon d'Egypte,
Pareillement au peuple Iſraëlite.

MOYSES & AARON aggrediuntur Pha-
raonem. Populus magis ac magis opprimi-
tur. Incusantur à populo Moyses & Aarõ.

EXODI V.

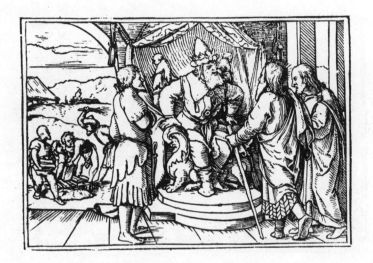

Auec son frere est Moyse adreßé
Vers Pharaon, priant pour Israël:
Mais plus en plus fut le peuple opreßé
Par celluy Roy, & son peuple cruel.

C iij

PHARAO induratus, insequitur Israëlitas &
submergitur. Murmurant Israëlitæ, despe-
rantes de salute. Gradiuntur per medium
maris siccis pedibus. Parta uictoria D E V M
adorant.

EXODI XIIII. & XV.

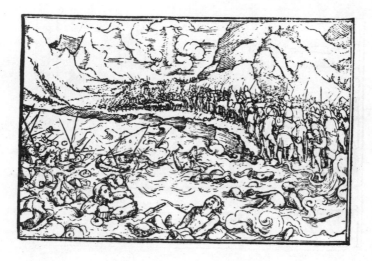

Tous les enfans d'Israël s'amasserent,
A beau pied sec la Rouge Mer passerent:
Et Pharaon en cruaulté plongé,
Les poursuyuant fut des eaux submergé.

ISRAELITAE in desertum Sin proficiscun-
tur. Murmurãtibus pro cibo, pluit DEVS
coturnices & man.

EXODI XVI.

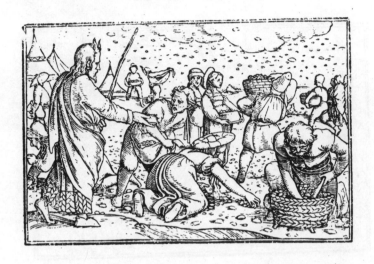

Iceulx passez, ilz se mectent en voye
Dans les Desertz : & pour mieulx les pouruoir,
Nostre Seigneur la Manne leur enuoye,
Qu'il leur faisoit du ciel en bas pluuoir.

ISRAELITAE ad montem Sinai castrame-
tantur. Iubetur populus sanctificari. In toni
tru & fulgure apparet DEVS, ut à populo
timeatur.

EXODI XIX.

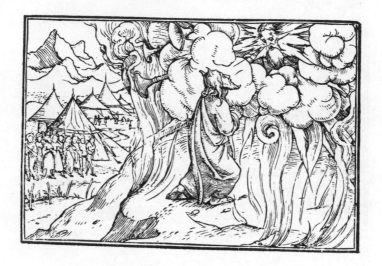

Ceulx d'Israël establirent leurs tentes
En Sinai, chascun se sanctifie.
Puis par tonnerre, & par fouldres patentes
Nostre Seigneur sa grandeur notifie

ISRAELITIS iubentur formari arca, men-
sa, & candelabrum ad primitias Domino
offerēdas. Panes Propositionis ad mensam
apponuntur.

EXODI XXV.

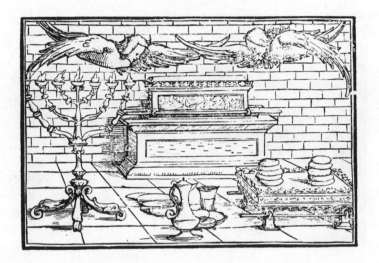

L'Arche se faict, la belle Table, aussy
Le Chandelier, par disposition
De nostre Dieu: sur ceste table cy
On mect les pains de Proposition.

D

MOYSES instauratis tabulis montem ascen-
dit. Orat DEVM ut cum populo gradia-
tur. Prohibetur societas gentium, & ido-
lolatria.

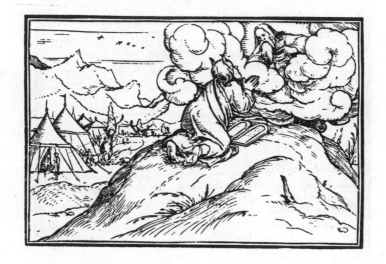

Dieu escripuit les Tables de la Loy:
Moyse enclin à deux genoulx, le prie
Pour Israël, en ferme & viue foy:
Dieu luy deffend payenne idolatrie.

MOYSES de offerendis armentis, pecoribus
& ouibus, è tabernaculo testimonij à Domi
no ritè instruitur.

LEVITICI I.

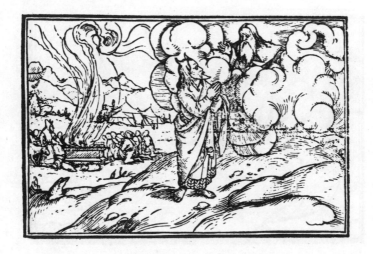

Dieu à Moyse enseigna son office,
Luy demonstrant par mandementz nouueaulx
Comme il conuient faire le sacrifice
Des gras moutons, des vaches, & des veaulx.

D ij

M O Y S E S iuſſu D O M I N I turba undiꝗ an-
te fores tabernaculi congregata, Aaronem
& filios eius conſecrat.

LEVITICI VIII.

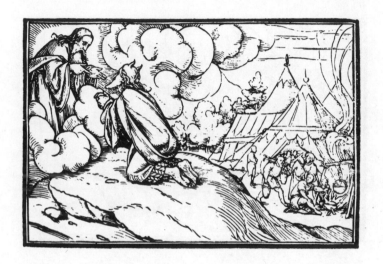

Au mandement de Dieu le Createur,
Preſent le peuple, Aaron fut ſacré
Sur Iſraël, grand Eueſque & paſteur,
Et tous ſes filz chaſcun en ſon degré.

NADAB & ABIV, Aaron filij, contra præ-
ceptum DOMINI ignem alienum offeren-
tes, flammis confumuntur.

LEVITICI X.

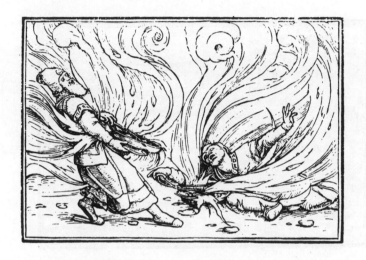

Nadab auec Abiu,pourautant
Q̃ùc feu eſtrange au Seigneur Dieu offreirent
Contre ſon vueil (leur orgueil abatant)
Par feu ſoubdain entre flammes perirent.
 D iij

MOYSI præcepta quædam moralia, & ceremonialia à Domino præcipiuntur.

LEVITICI XIX.

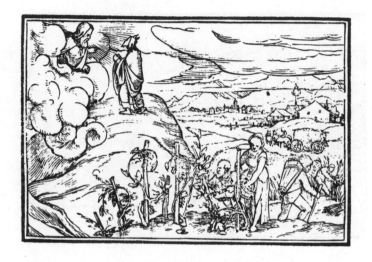

Deſſus le mont Dieu enſeigne à Moyſe
Ses mandementz, qui ſont les Loix morales:
Puis luy apprent l'obſeruance & la guiſe,
Pour accomplir les Ceremoniales.

M O Y S E S & A A R O N uiros ad pugnam
aptos , iuxta duodecim tribus Iſraël nume-
rant. Tribus Leui ſuper tabernaculum con-
ſtituitur.

<center>N V M E R I I.</center>

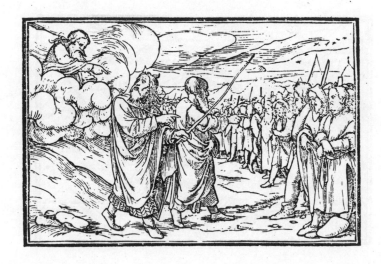

Moyſe eſlit & nombre entierement
Les hommes fortz de vaillance ennoblis :
Ceulx de Leui ont le gouuernement
Du Tabernacle ou ilz ſont eſtablis.

MOYSES & AARON recensitis familiaru̅
principibus iuxta ma̅data DEI, caftrorum
ftationes ordinant.

NVMERI II.

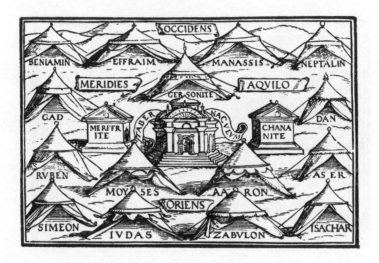

Apres Moyſe (au mandement de Dieu)
A ceulx qui ſont des familles les princes,
Il ordonna leur aſſiete & leur lieu,
En trauerſant les pays & prouinces.

CORE, DATHAN, & ABIRON, in Moy
sen murmurantes, absorbentur cum multis
à terra.

NVMERI XVI.

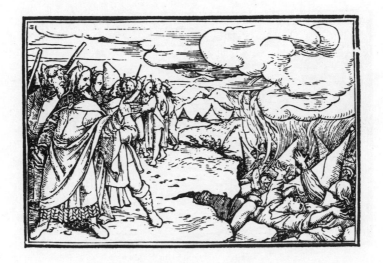

Core, Dathan, & Abiron murmurent
Contre Moyse, & son authorité :
Mais tout subit en terre absorbez furent,
Comme chascun auoit bien merité.

E

ISRAEL rebellis ſerpentibus ignitis percu-
titur. Serpentem æneum pro ſigno erigit
Moyſes: quem cum percuſsi aſpiciunt, ſa-
nantur.

NVMERI XXI.

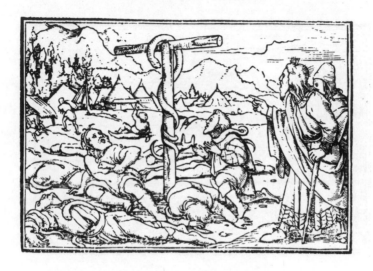

Chaſcun qui fut d'aucun ſerpent greué
Pour y trouuer remede ſouuerain,
Eſtoit guery, quand il auoit leué
Le ſien regard uers le ſerpent d'ærain.

ISRAELITAE uictis Madianitis, prædam
afferunt ad Moysen & Aaron. Virginibus
reseruatis, mulieres interficiutur. Præda ex
æquo diuiditur.

NVMERI XXXI.

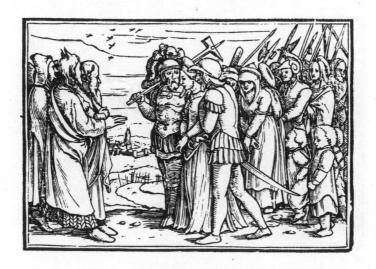

En dur conflict sont les Madianites
Du tout uaincus par les Israëlites :
Sauuant la uierge est toute femme occise,
Et puis entre eulx la proye se deuise.

E ij

MOYSES in solitudine campestri, Israëlitis
quæ gesta fuerant à monte Horeb, repetit.
Principes populo secum constituit.

DEVTER. I.

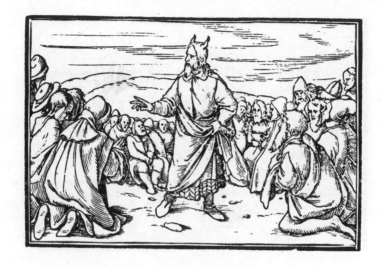

Moyse à tous repete briefuement
Ce qui s'est faict depuis leur partement
Du mont Horeb. Et puis il institue
Des Gouuerneurs, qu'auec luy constitue.

M O Y S E S de discendis & faciēdis D E I præ
ceptis, non modò apertè, sed etiam aciiter
populum monet.

DEVTER. IIII.

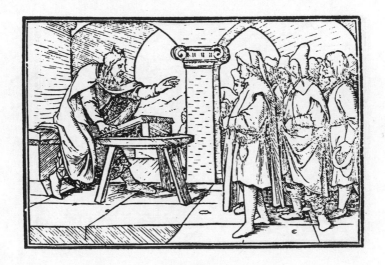

Moyse apres aigrement admonneste
Ceulx d'Israël d'apprendre & obseruer
La Loy de Dieu, qui est tant pure & nette,
Et ses preceptz (tant bien faictz) conseruer.

E iij

MOYSES de Sacerdotum & Leuitarum ui-
ctu solicitus decernit. CHRISTVS pro-
mittitur. Pseudopropheta occidendus, &
quomodo dignoscendus.

DEVTER. XVIII.

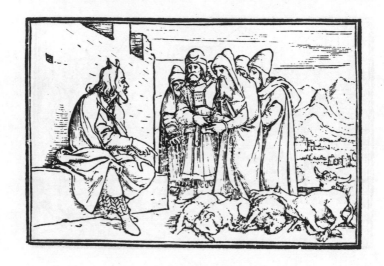

Moyse à soing du uiure des Leuites,
Et IESVCHRIST est aux hommes promis:
Le faulx prophete à mort doibt estre mis,
Qui est congneu par ses meurs hipocrites.

IOSVE cum Israëlitarum exercitu,trans Ior-
danem reges interficit.

IOSVE XII.

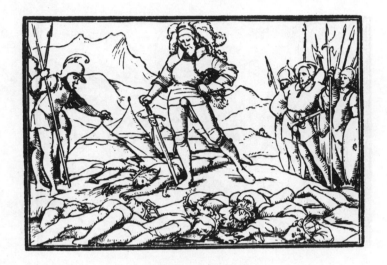

Iosue duc d'Israël quand il eut
Passé Iourdain auec son exercite,
Trente & vn Roy il occit,puis esleut
La terre aux siens,& chascun lieu limite.

IVDAS dux Israëlitarum expugnat Chana-
næos. Adonibezec cæsis manuũ ac pedum
summitatibus, in Ierusalẽ captiuus ducitur.

IVDICVM I.

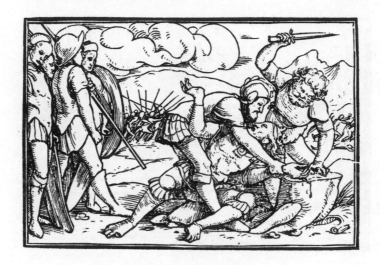

Le duc Iudas Chananée guerroye,
Puis apres fut Adonibezec pris,
Mains, piedz tranchez, tout lié & surpris
En la cité Ierusalem l'enuoye.

R ᴠ ᴛ ʜ colligens ſpicas in agro Booz, inue-
nit gratiam coram eo. Collectas ſpicas de-
fert ad ſocrum.

RVTH II.

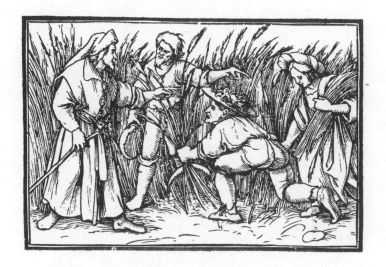

Ruth va aux champs les eſpicz recueillir,
Au moins ce qui des moiſſonneurs reſtoit:
Alors Booz à qui le champ eſtoit
En grand doulceur vint la dame accueillir.

F

A N N A Elcanæ uxor diu sterilis, Heli sacer-
dote super sellam ante postes templi Domi
ni sedente, corde orans, à D E O filium Sa-
muelem impetrat.

<center>I. R E G V M I.</center>

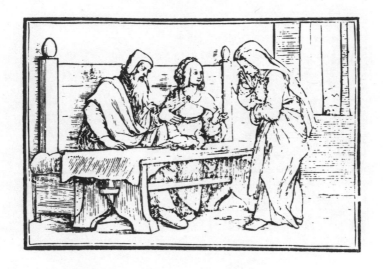

Anne ne peut d'Elcana son mari
Auoir enfant, parquoy en cœur marry
Gecte ses pleurs : de Dieu tel don receut
(L'ayant prié) que Samuel conceupt.

SAVL à Samuele ungitur in Regem super Is-
raël. Iuxta sepulchrū Rachel datur ei signū,
quo se à DEO in Regem unctum credat.

I. REGVM X.

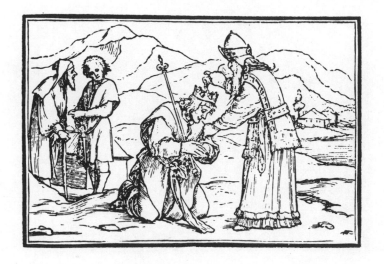

Saul est oingt & faict Roy d'Israël
Par le tresbon prophete Samuel :
Pres le tumbeau de Rachel voit le signe
Comme de Dieu il est faict roy tresdigne.

F ij

DAVID Saulis armis reiectis, ac folius DEI
potentia confifus, lapide funda iacto Go-
liath interficit, Philifthæos in fugam uertit.

I. REGVM XVII.

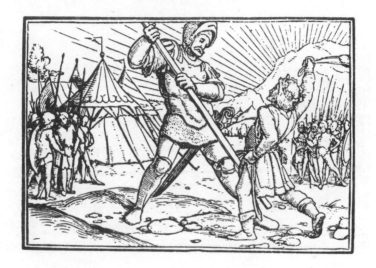

Dauid petit en Dieu fe confiant,
Sans eftre armé, faict tant que d'vne pierre
Goliath tue, & le gecte par terre,
Des Philifthins l'Oft retourne fuyant.

DAVIDI nuntiatur Philisthæos Ceilam op
pugnasse, & areas diripuisse : qui consulto
bis Domino, Ceilam à Philisthæis liberat.

I. REGVM XXIII.

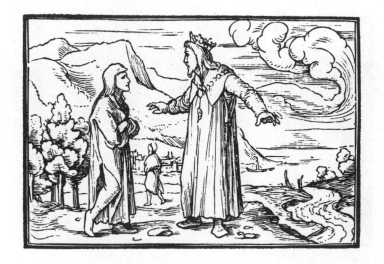

On.annonce au preux David comment
Des Philisthins est Ceile assaillie :
Du vueil de Dieu il faict sur eulx saillie,
Et la mect hors de leurs mains promptement.
F iij

DAVIDI mors Saulis & Ionathæ nuntia-
tur. Triſtatur Dauid, ac eum qui mentitus
fuerat ſe occidiſſe Saulem, occidi iubet.

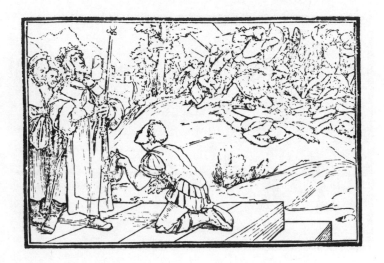

Vng meſſagier à Dauid faict rapport
Comment Saul auec ſon filz eſt mort,
Lors feit tuer celluy (de ſens raſſis)
Qui dit auoir le roy Saul occis.

DAVID Philisthæos profligat, eosq; sibi tributarios facit. Adarézer Rex Soba percutitur.

II. REGVM VIII.

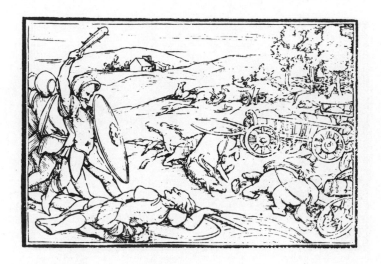

Le Roy Dauid faict à luy tributaires
Les Philisthins ses mortelz aduersaires : -
Adarezer roy de Soba aussi
Rendit vaincu, roide, mort, & transi.

DAVID ab exercitu Vriam reuocat, ut cum uxore dormiens celaretur adulteriũ. Vrias, acceptis à Dauide literis, ad exercitũ remittitur, & ibi occiditur.

II. REGVM XI.

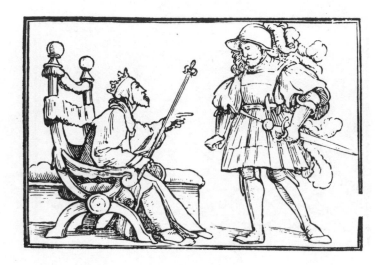

Dauid voulant l'adultere celer
Mande Vrias, & luy baille vne letre:
Puis luy commande à la bataille aller,
Par telle fraulde il le fcit à mort mettre.

D A V I D arguitur homicidij à Nathan, pro-
posita illi parabola diuitis & pauperis. Rab
bath urbs Ammonitarum à Dauide expu-
gnatur.

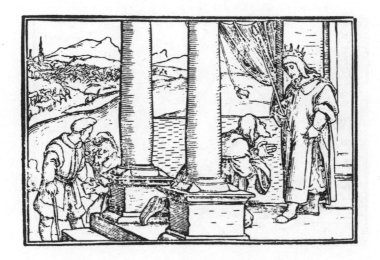

Nathan addresse à Dauid sa parolle
Pour l'homicide ayant esté commis,
Et le reprint par vne parabolle:
Deuant Rabbath aussi le siege est mis.

G

ABSALOM astu & prudentia Ioab, & mulie
ris Thecuitidis reuocatur. Ioab messe suc-
censa, introductus Absalom à patre oscu-
latur.

II. REGVM XIIII.

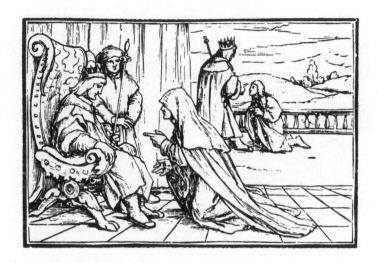

Par sa prudence vne femme faict tant
Auec Ioab,que Dauid se rapaise
Vers Absalom,qui vient en s'aquictant
S'humilier,& son pere le baise.

A M A S A cõuocat Iudam cõtra Sebam:quem
osculatus Ioab,in itinere iuxtã lapidẽ gran-
dem dolosè interficit.

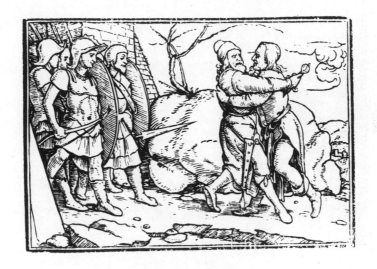

Amasa vient d'assembler gens de guerre
Contre Seba : Ioab à sa venue
Par trahison doulcement le salue,
Et le tua aupres de la grand pierre.
 G ij

A BISAG puella pulchra seni Dauidi frigido
datur, quæ cum dormientem calefaciat.

III. REGVM I.

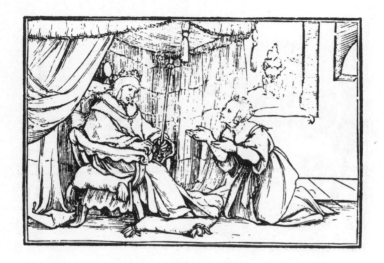

Quand Dauid fut deuenu foible & vieulx
On luy bailla Abisag la pucelle,
Pour l'eschauffer : lors coucha auec elle,
Sans y auoir aucun faict vicieux.

HIRAM mittit seruos ut gratuletur Salomo-
ni. Salomon petit ligna ab Hiram in ædifi-
cationem templi.

III. REGVM V.

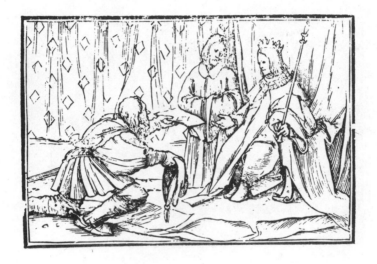

Le roy Hiram ses seruiteurs enuoye
Vers Salomon, auec salut tresample :
Lors le requiert Salomon en grand ioye
Luy donner bois pour construire son temple.

 G iij

IEROBOAM confulit Ahiam prophetam,
per uxorem, de ualetudine filij ægroti. At il
la rcuerfa, ac limen domus ingrediéte, Abia
moritur.

III. REGVM XIIII.

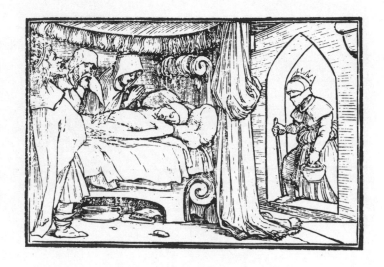

Ieroboam enuoie fon efpoufe
Vers Abias, qui la mort luy propofe
De fon enfant : lors quand elle retourne
Entrant par l'huys l'enfant à mort fe tourne.

ELIAS oftendit facerdotibus Baal, Deum
Ifraël effe uerum Deum, Deo id teftificante
per ignem confumentē holocauftum Eliæ.
Sacerdotes Baal interficiuntur.

III. REGVM XVIII.

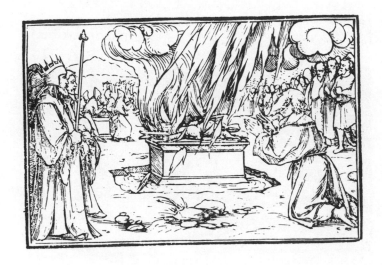

Elie meēt le bœuf deffus l'autel,
Et pour monftrer que le Dieu d'Ifraël
Eft le vray Dieu, le feu fans artifice
Defcend du Ciel bruflant le facrifice.

ELIAS diuidit aquas pallio. Raptus in cœlum non inuenitur. Eliseum irridentes pueri, lacerantur ab ursis.

IIII. REGVM II.

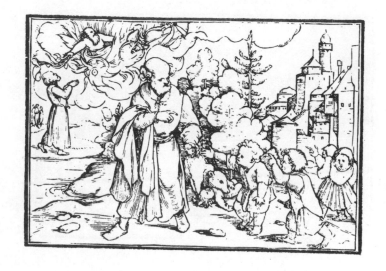

Vn chariot de feu ardant rauit
Le bon Elie, & plus on ne le veit.
Enfantz sont mortz, & des Ours suffoquez
Car ilz s'estoient d'Elisee mocquez.

IOIADA pontifex, Athalia occiſa, conſtituit
Ioas regem ſuper Iſraël. Mathan ſacerdos
Baal coram altari interficitur.

IIII. REGVM XI.

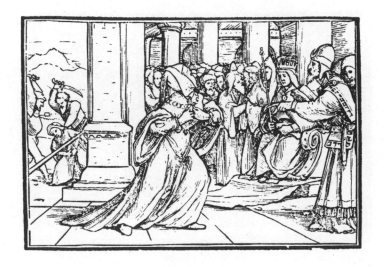

Par Ioiada, Ioas conſtitué
Sur Iſraël fut en l'eſtat Royal :
Et lors Mathan le prebſtre de Baal
Pres ſon autel fut tout ſubit tué.

H

A c h a z rex Iuda idololatra, confecrat filium
fuum per ignem. Ierufalem obfeffa, petit au
xilium à rege Affyriorum.

IIII. REGVM XVI.

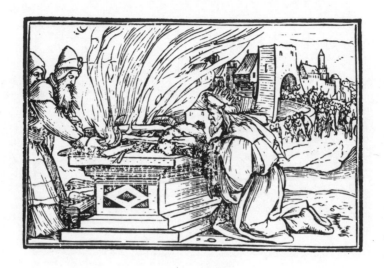

Le roy Achaz idolatre deuint,
En feu ardant fon filz il facrifie:
Puis quand la guerre encontre luy furuint,
Seccurs demande au grand roy d'Affyrie.

IOSIAS legit Deuteronomium coram po-
pulo. Idola demolitur, & facerdotes Baal
interficit.

IIII. REGVM XXIII.

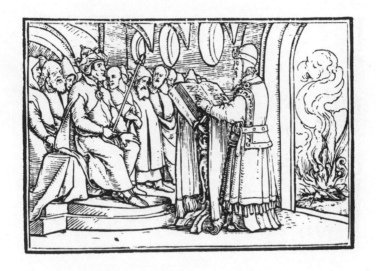

Le Roy Iofie au peuple Iudaique
Deuteronome il lit de bout en bout:
Puis faict brufler les idoles par tout,
Et fon pays purge d'erreur inique.

H ij

A D A M genealogia uſque ad filios Eſau & Ia
cob, breuiter repetitur.

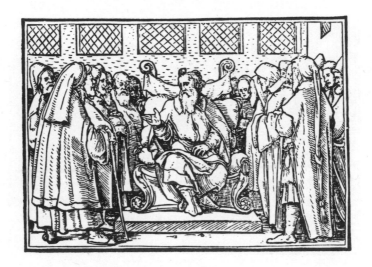

Icy recite & nombre brieſuement
Depuis Adam, des le commencement
Iuſqu'à Iacob, la genealogie,
Qui fut ſoubz Dieu gouuernée & regie.

S A V L côtra Philiſthæos infeliciter pugnans,
ſeipſum interimit. Eius arma in tēplo Dei
ſui conſecrantur:caput uerò à Philiſthæis in
templum idolorum deſertur.

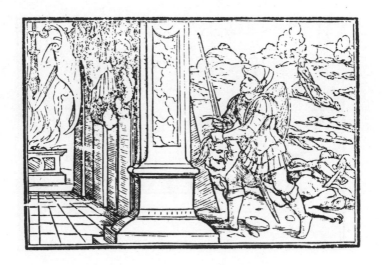

Saul faiſant la guerre aux Philiſthins
Soymeſme occit quand ſa perte contemple:
Les Philiſthins entre tous leurs butins
Portent le chef de Saul en leur temple.

H　iij

DAVID allata Arca benedicit populo, quem
etiam cibat. Miniſtros Arcæ ad laudādum
DEVM in inſtrumentis muſicis conſtituit.

I. PARALIP. XVI.

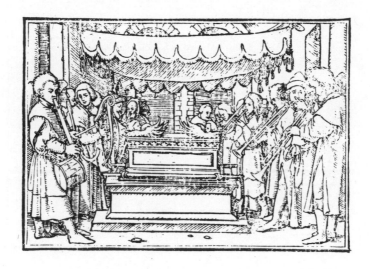

Le Roy Dauid deuant l'Arche de Dieu
Beneict le peuple, & à manger luy donne:
Muſiciens pour Dieu louer ordonne,
Iouantz touſiours d'inſtrumentz en ce lieu.

SALOMON in excelſum Gabaon ſacrifica-
turus abit. Petit à DEO ſapientiam & ſcien
tiam ad iudicandum populum.

II. PARALIP. I.

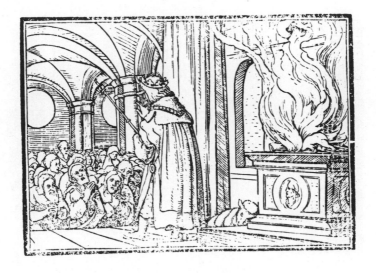

En Gabaon Salomon ſacrifie,
Puis prie à Dieu de luy donner ſageſſe :
Dieu parle à luy, & ſi luy certifie
Qu'il luy donra Sapience & Richeſſe.

SALOMON benedicit congregationi. Gra-
tias agit ob impletas promissiones Dauidi
factas. Orat ut exaudiantur in templo orates.

II. PARALIP. VI.

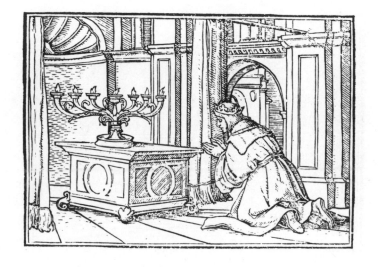

Salomon Roy beneict les assistans,
Rend grace à Dieu, des promesses parfaictes,
Priant pour ceulx qui seront persistans
Es oraisons, qu'agreables soient faictes.

S E S A C rex Aegypti, ob derelictum à Iudæis
Dominum, clypeos aureos, quos fecerat Sa
lomon, omnesᷓ thesauros domus D E I se-
cum aufert.

I I.　P A R A L I P.　X I I.

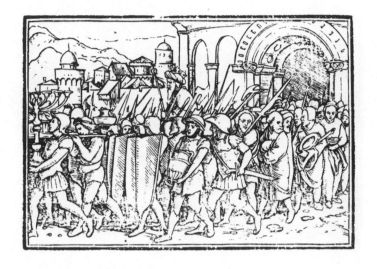

Les Iuifʒ auoient laißé noſtre Seigneur :
Tumber les feit en vn tel deshonneur,
Qu'vn roy d'Egypte auec ſes cheualiers,
Print leurs-threſors & leurs riches boucliers.

I

SENNACHERIB blasphemus inuadit Iu-
dam. Ezechias hortatur populum ad fidu-
ciam in DEVM. Orante Ezechia, Angelus
Assyrios persequitur.

II. PARALIP. XXXII.

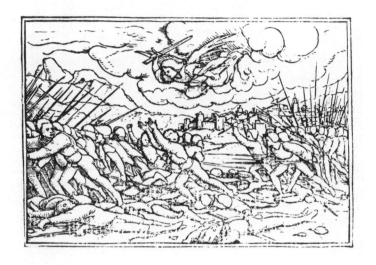

Sennacherib en Iudée faict guerre,
Ezechias le peuple en Dieu exhorte:
Dieu par vn Ange en sa puissance forte,
Les ennemis mett tous à mort par terre.

C Y R V S à D E O inspiratus, redditis uasis tem
pli , quæ abstulerat Nabuchodonosor , re-
mittit populum ad ræædificandã Ierusalem.

I. ESDRAE I.

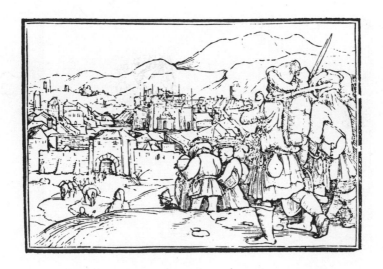

Le roy Cyrus de Dieu bien inspiré,
Rend les vaisseaulx pour faire au temple office :
Puis il permit, comme estoit desiré,
Ierusalem estre en son edifice.

I ij

NEHEMIAS pincerna regis Artaxerxis,
pro populo afflicto qui de Ierusalem super-
erat, DEVM orat.

II. ESDRAE I.

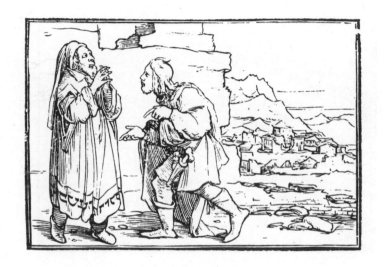

Nehemias seruant Artaxerxes,
(Pleurant à Dieu, pour la captiuité
De tous les Iuifz) eut au Roy tel acces,
Qu'il luy permist refaire la cité.

IOSIAS quartadecima luna primi mensis, in
Ierosolymis immolat Phase.

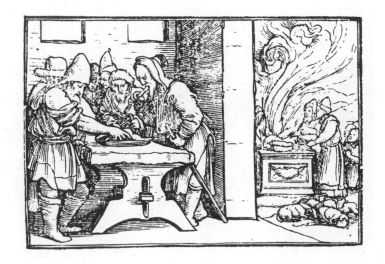

Iosias Roy, lequel se remembra
Du temps passé, le Seigneur Dieu inuocque:
Au premier mois, tout le peuple conuocque,
Auec lequel la Pasque celebra.

I iij

TOBIAS captiuus inter Aſſyrios ducitur.
Obdormienti iuxta parietem, hirundinum
ſtercora calida ſuper oculos eius cadunt, ac
cæcus efficitur.

TOBIAE I. & II.

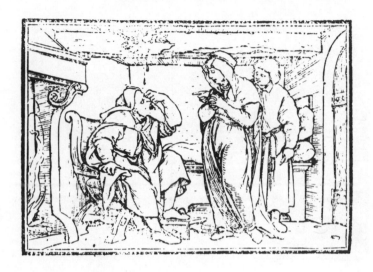

Le bon Thobie eſtant captif & vieulx
Dormoit vn iour, & lors vne Arondelle
Eſtant là pres, fienta ſur ſes yeulx,
Dont perd la veue & la clarté tant belle.

I O B bona omnia diſsipat Satan, & eius libe-
ros percutit, expetita facultate à Domino.
Laudat D E V M in ſua afflictione.

IOB I.

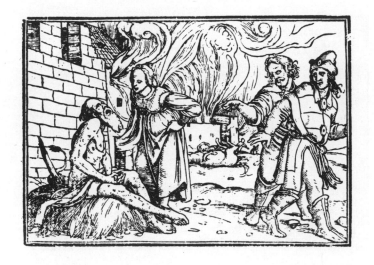

Iob par Satan (ayant de Dieu licence)
Seuffre en ſes biens grand perſecution:
Ses enfans perd, dont il a patience,
Louant ſon Dieu en telle affliction.

ELIPHAZ arguit Iob de ſapientiæ & mun-
ditiæ arrogantia. Deſcribit impiorum ma-
ledictionem, quam falſò Iob innocenti tri-
buit.

IOB XV.

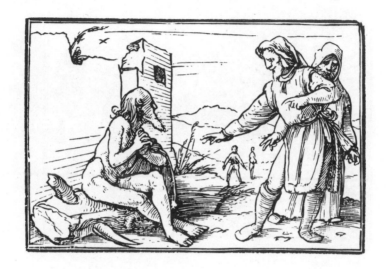

Iob affligé & au corps & aux biens,
Fut argué de trop grande arrogance
Par Eliphaz, don n'eſt coulpable en riens,
Et faulſement trouble ſon innocence.

IOB alloquitur Dominus, oftendens ei fuam
iuftitiam ex infcrutabilibus fuis operibus.
Iob duplicia pro ablatis reftituuntur.

IOB XXXVIII. & XLII.

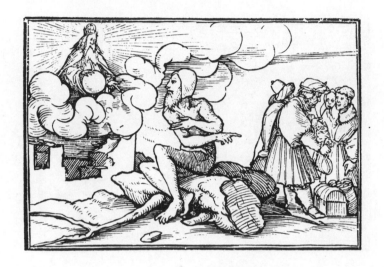

Iob a de Dieu les propos entendus
Et les fecretz de fes œuures haultaines,
Et pour les biens qu'il auoit tous perdus
Augmente au double en richeffes mondaines.

K

ASSVERVS, celebrato conuiuio, potentiam
& gloriam suam ostentat. Vasthi uxore re-
pudiata, Esther regina efficitur.

ESTHER I. & II.

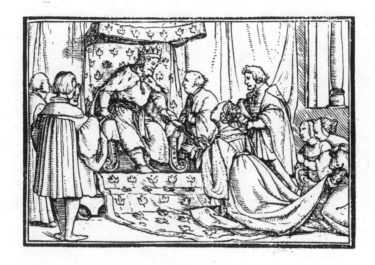

Assuerus celebrant vn conuiue
Repudia Vasthi pour son orgueil,
Hester trouua en sa beaulté si viue
Qu'il la feit Royne auec vn grand recueil.

IVDITH oratione abſoluta, ueſtimentis iu-
cunditatis exornat ſe, ut Holofernem uin-
cat in DEI gloriam.

IVDITH X.

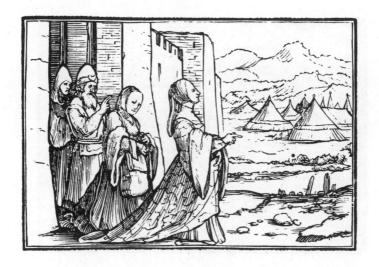

Iudith apres auoir l'oraiſon faicte
Se meſt à point, & vers les tentes va
D'holofernes, lequel elle trouua
Et eut ſur luy victoire treſparfaicte.

 K ij

IVDITH, Holoferne ebrietate sopito, & puel
la ostium obseruāte, caput eius præscindit,
& ciuibus suis defert.

IVDITH XIII.

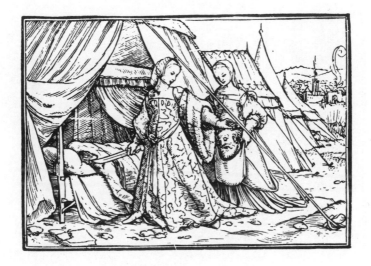

Holofernes plain de vin & tout yure
S'endort au lict apres ioyeuse feste,
Et lors Iudith luy vint trencher la teste
Qu'en Bethulie aux citoiens deliure.

DAVID spiritu DEI afflatus, Beatitudines
uiri describit. Impiorum quoque & infide-
lium interitum prædicit.

PSALM. I.

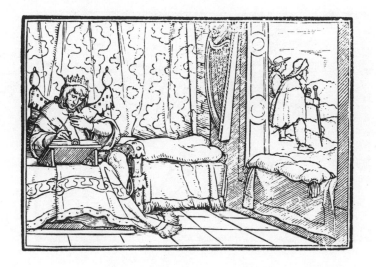

Dauid parlant par le sainct Esperit,
Du Bienheureux dict les beatitudes :
Et du Mauuais recite qu'il perit,
Car en malice il a mis ses estudes.

K iij

PSALTES contra Iudæos excãdefcit, ac eos
qui CHRISTVM Mefsiam DEVM in le-
ge promiffum infideliter & impiè negant,
infipientes uocat.

PSALM. LII.

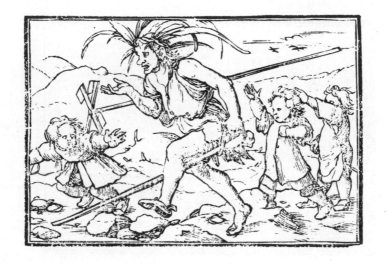

Folz font ceulx là (comme efcrit le Pfalmiste)
Qui en leurs cœurs dient que IESVCHRIST
N'eft Meßias : Dauid tant fen contriste
Qu'en plufieurs lieux encontre eulx l'a efcrit.

CHRISTVS sedet ad dexterã patris. DEVS
pater filio suo sacerdotalem dignitatem in
æternum duraturam ex passionis præmio
tradit.

PSALM. CIX.

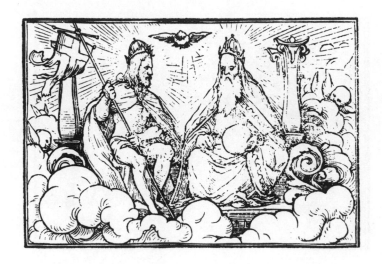

Le CHRIST s'aßiet de son Pere à la dextre,
Qui pour loier de sa mort trescruelle
La dignité luy donne du grand Prebstre,
Qui est sans fin durante & eternelle.

CHRISTI erga sponsam suam ecclesiam, ac rursum sponsæ erga CHRISTVM incomprehensibilis amoris mysteriũ plenissimum exprimitur.

CANTICOR. I.

Salomon dit au liure des Cantiques
De son amye aucuns secretz mystiques,
De IESVCHRIST la grand amour expose
Qu'il a auec l'Eglise son espouse.

ISAIAS deplorat peccata Ierusalem. Ceremo
nias & cultus Iudæorum, quibus ipsi fide-
bant, per Isaiam reijcit Dominus.

ISAIAE I.

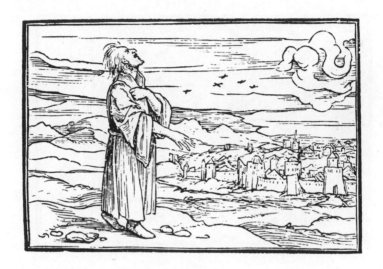

Du peuple Iuif les grandz pechez & vices
Pleure & lamente Isaie prophete,
Puis Dieu (par luy) de ce peuple regecte
L'hipocrisie auec leurs sacrifices.

 L

ISAIAS uidet gloriam DEI, ac peccatum
suum agnoscit. Signo & uerbo remissionē
peccatorum consequitur, & ad Iudæos mit
titur.

ISAIAE VI.

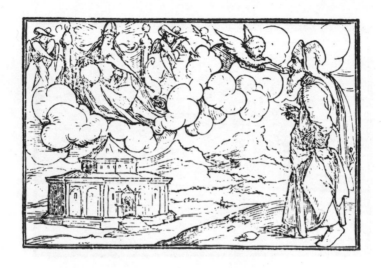

De Dieu la gloire Isaie appercoit,
De son peché il a la congnoissance,
Remission s'ensuit apres l'offense,
L'Ange le touche, & lors pardon recoit.

EZECHIAS ad mortem ufque ægrotat.
Signum fanitatis à Domino in horofcopo
accipit.

ISAIAE XXXVIII.

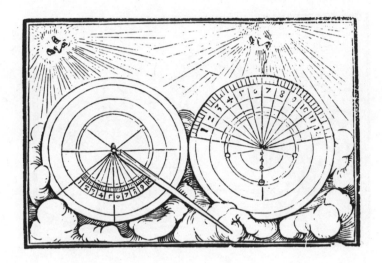

Ezechias iufqu'à la mort malade
En l'horofcope eut figne de fanté :
Contre fon cours le foleil retrograde
De dix degrez ou il eftoit planté.

L ij

EZECHIELIS quatuor animalium, rota-
rum, throni & imaginis super thronum ui-
siones.

EZECH. I.

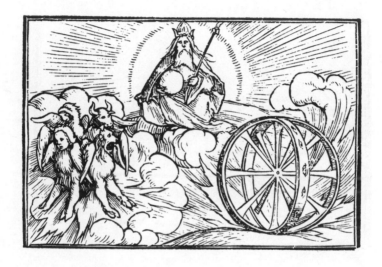

Ezechiel void en sa vision
Dieu en son throne auec les quatre bestes:
L'Aigle, le Bœuf, & l'Homme, & le Lion,
Roues aussi de tourner tousiours prestes.

EZECH. XL.

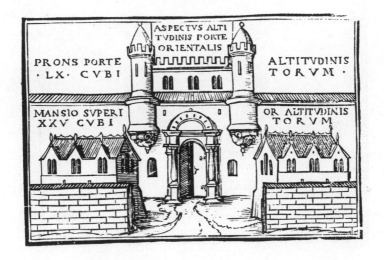

Monſtré luy eſt en contemplation
De ſon eſprit, par viſion treſample,
A l'aduenir, la reſtauration
De la Cité & du ſouuerain Temple.

L iij

EZECHIEL uidet gloriam DEI templum
ingredientem à quo antè recesserat. Altaris
mensuræ describuntur.

EZECH. XLIII.

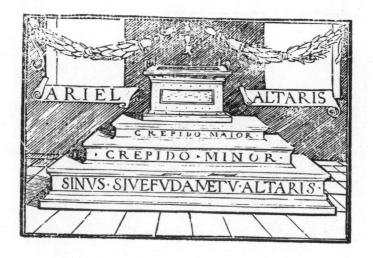

Puis void apres, du grand Dieu immortel
La haulte gloire en ce sainct temple entrer:
Apres descript & s'efforce a monstrer
La longitude & grandeur de l'autel.

EZECHIEL uidet aquas è Templo manantes. Termini terræ promiſsionis, & diuiſiones per Tribus à Domino Prophetæ oſten
duntur.

EZECH. XLVII.

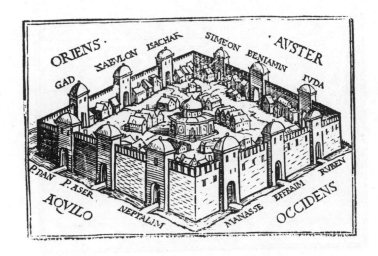

Autour du temple il void eaux demourantes,
De l'Orient vers le Midy courantes :
Puis des Tribus void la diuiſion,
Dans le pays dict de Promiſſion.

SIDRACH, MISACH, & ABDENAGO,
quòd statuam auream contra decretum re-
gium nõ adorauerint, in fornacē mittuntur.

DANIELIS IIII.

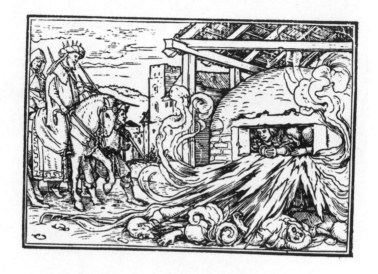

Sidrach, Misach, Abdenago sont mis
Au four ardant, car le roy l'institue,
Pource qu'ilz n'ont adoré sa statue,
Mais Dieu en fin deliure ses amis.

DANIELI uisio quatuor animalium often-
ditur. Hæc autem uisio de quatuor mundi
regnis interpretatur.

DANIELIS VII.

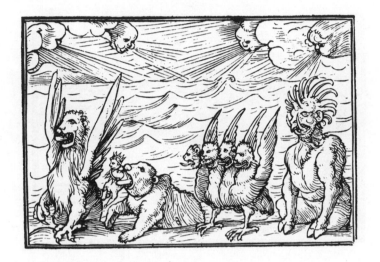

Daniel void les quatre ventz combatre,
Beſtes auſſy, iuſqu'au nombre de quatre :
Lors luy fut dict, Si de ſçauoir aſpires,
Ces beſtes ſont du monde quatre empires.

M

DANIEL uidet pugnam inter arietem & hir-
cum. Visionis intelligentia Danieli ab An-
gelo manifestatur.

DANIELIS VIII.

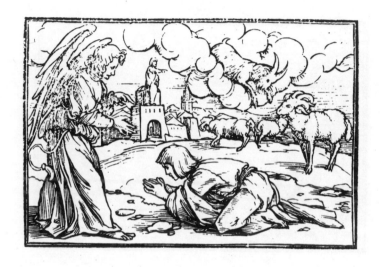

Il void apres vne bataille forte
Entre vn mouton, & vn bouc tout cornu :
L'Ange exposant la verité rapporte
En luy disant ce qui est aduenu.

DANIELI uaticiniū de regibus Persarum,
regno Græciæ, Aegypti, & fœdere eius &
bello cum regno Syriæ prædicitur.

DANIELIS XI.

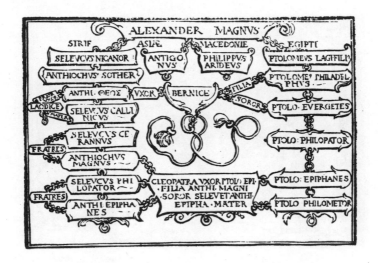

Puis il predit des faictz des roys de Perse,
De Grece, Egypte, & des roys de Sirie,
Prophetisant mainte guerre diuerse
Pour agrandir chascune seigneurie.

M ij

SVSANNAE presbyteri duo calumniatores
à Daniele couicti, lege talionis plectuntur.

DANIELIS XIII.

Susanne fut accusée à grand tort
De deux vieillardz, mais par raison decente
Est deliurée ainsi comme innocente,
Et Daniel les vieillardz iuge à mort.

DANIEL propter Belis & Draconis euer-
sionem, conijcitur in lacum leonum. Pascit
eum Habacuc.

DANIELIS XIIII.

Le grand Dragon auec l'idole Bel
Furent destruictz par le bon Daniel :
Dedans le lac aux Lions il est mis,
Pour le nourrir est Habacuc commis.

M iij

OSEE accepta uxore fornicaria idololatriam
populi significat.

OSEE I.

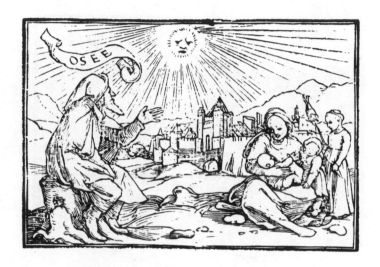

Osee prend & espouse vne femme
Fornicatrice, & trois enfant eut d'elle :
Signifiant l'idolatrie infame
Du peuple Iuif, à son Dieu peu fidele.

IOEL destructionem Ierusalem prædicit. Sacerdotes ad orationem & ieiunium, ob instantem calamitatem, assiduè adhortatur.

IOELIS I.

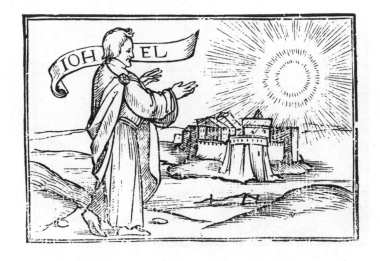

Ioël predit de la destruction
Ierusalem, & aux prebstres supplie
Vacquer à iceusne, & oraison remplie
D'humilité & de deuotion.

A M O S I.

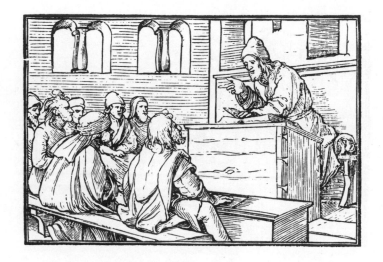

Contre Damas, Philiſtins, Idumée,
Et contre Tir, auec les filz Ammon,
Sa prophetie Amos ſi a ſemée
En brief parler, & ſoubz obſcur ſermon.

I O N A S miſſus in Niniuem ad prædicãdum,
affligitur, quòd ſermo eius contra Niniuem
non fuerit impletus.

IONAE I. II. & III.

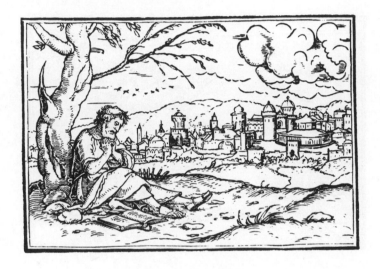

Ionas tranſmis en Niniue preſcher
Fut affligé par tempeſteſoubdaine:
Trois iours au ventre il fut d'vne Balaine,
Puis vers Niniue il ſe print à marcher.

HABACVC pulmentum & panes meſſori-
bus ferens,in perſona ſanctorum piè cõque-
ritur,quòd mali iuſtos perſequantur.

HABACVC I.

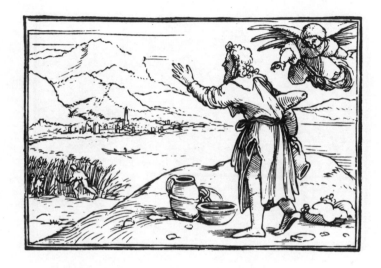

Portant des pains Habacuc le prophete
Aux moiſſonneurs & laboureurs des champs,
Se plaingt à Dieu de ce que iniure eſt faicte
Aux gens de bien par les felons meſchantz.

ZACHARIAS monet populum ut conuertatur ad Dominū, & parentum scelera uitet.

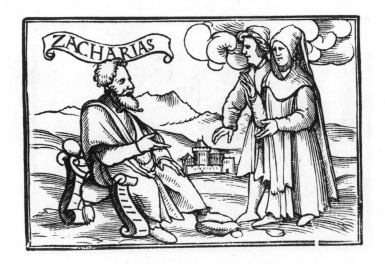

Zacharias tout le peuple admonneste
Se conuertir au Seigneùr Dieu puissant,
Et euiter le peché deshonneste
De ses parentz, ou est chascun glissant.

N ij

ANTIOCHO secundam profectionẽ in Ae-
gyptum parante, Ierosolymis signa in cœle
ítibus apparuere.

II. MACHAB. V.

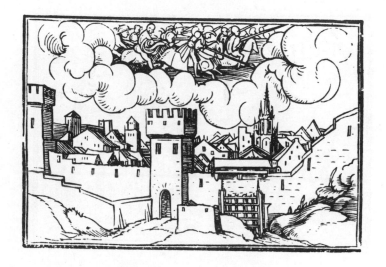

Antiochus faisant aux Iuifz la guerre,
On veid au ciel dessus Ierusalem
Hommes armez, tout ainsy qu'en la terre,
Lors prinse fut par les Iuifz en mal an.

Au Lecteur S.

Quand vous aures contemplé ces Images
Du Dieu viuant ayez en souuenir
La grand' puissance, & merueilleux ouurages,
Et sa bonté qui nous peult subuenir.
 Ce nous sera proufict à l'aduenir
D'estudier telle philosophie:
Vueillez le sens de l'Eglise tenir,
La Letre occit, & l'Esprit viuifie.

Plus que moins.

Lugduni,
Sub ſcuto Coloniēſi
apud Io. & Franc.
Frellonios, fratres.
1 5 4 3